20 WAYS TO DRAW A CHAIR

AND 44 OTHER INTERESTING EVERYDAY THINGS

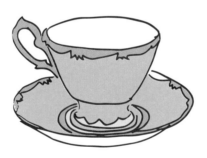

LISA SOLOMON

A Sketchbook for Artists, Designers, and Doodlers

Quarry Books
100 Cummings Center, Suite 406L
Beverly, MA 01915

quarrybooks.com • www.craftside.net

© 2015 by Quarry Books
Illustrations © Lisa Solomon

First published in the United States of America in 2015 by
Quarry Books, a member of
Quarto Publishing Group USA Inc.
100 Cummings Center
Suite 406-L
Beverly, Massachusetts 01915-6101
Telephone: (978) 282-9590
Fax: (978) 283-2742
www.quarrybooks.com
Visit www.Craftside.net for a behind-the-scenes peek at our
crafty world!

10 9 8 7 6 5 4 3 2 1

ISBN: 978-1-63159-061-0

Design: Debbie Berne

Printed in China

CONTENTS

INTRODUCTION

This book, *20 Ways to Draw a Chair and 44 Other Interesting Everyday Things,* is an ode to all the sometimes over-looked items that surround us and make our living spaces uniquely ours. The still life has been a part of artwork since the dawn of time. The drawings in this book are in many ways a tribute to this time-honored tradition. We are surrounded by potential subjects in every room of our home. Grab something from the kitchen or sit across from your sofa and draw it.

scissors: charcoal and ink

This book will hopefully remind you that there is always something nearby to draw. And, through the act of drawing, we begin to see and understand things in new ways. There is something gratifying about seeing the familiar with fresh eyes; in finding elegance in the simple curve of a spoon. When we stop to look, these things that we might just take for granted in our day-to-day lives have a lot of variation and character. There's the "happy" chair, the "serious" one, the "stuck-up" teacup, and the "sultry" scissors.

HOW TO USE THIS BOOK

I approached drawing these objects as an exploration of the domestic shape, mark making, and idea of each collection. What kinds of lines and textures do you need to minimally represent an object? What happens when you go all out and try to capture more detail? What happens when you change your point of view—look from the right, from the left, from above, or from below? What happens when you add color? Oh, the magic of color! Do you understand benches more after drawing twenty of them? I have to say, indeed I do.

I once spent a year doing a drawing in my sketchbook everyday of something that was left on a table or a countertop in my house. The beauty of the things we choose to surround ourselves with sometimes escapes us. We forget that moment when we fell in love with a particular chair or a teacup. I have found that drawing objects reinvigorates my passion for them. This daily act of drawing also kept me connected to my artist practice.

lamps: acrylic ink and pencil

The spreads of this book are designed to allow you space to explore and try your own drawings. Copy something you see on the page, or find something in your house to draw alongside what is already there.

Experiment with materials. Draw with charcoal, ink, pen, pencil, or marker. Find an excuse to go to the art supply store and buy new materials that you've always wanted to try. If you normally draw neatly, draw messy—and vice versa. Try drawing upside down—you'll be amazed by what happens! Even try drawing with your "wrong" hand. Draw the same object with long, singular lines, and then short, fast ones. Try to see if you can come up with a shorthand—a drawing vocabulary. What happens if you make a small V mark and use it to fill up some space? Just be open. Look closely. Let go of the idea of right or wrong, of making mistakes, and just draw!

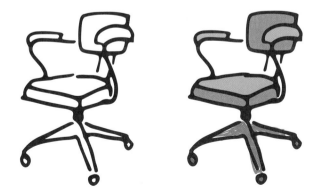

office chairs: gouache and micron pen

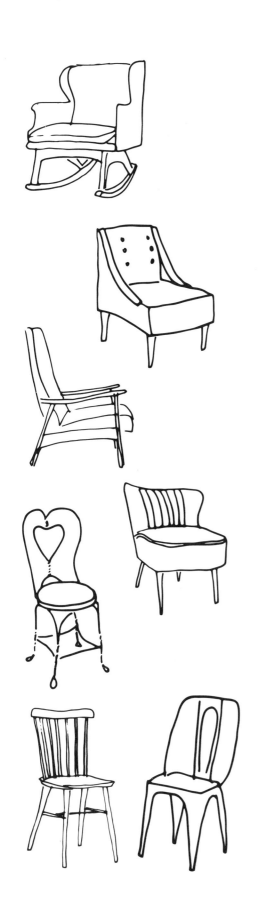
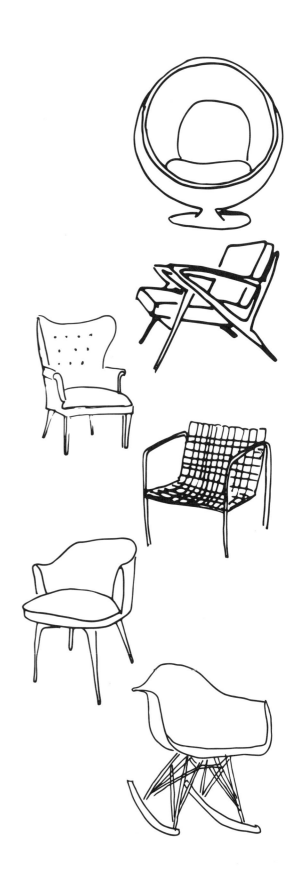

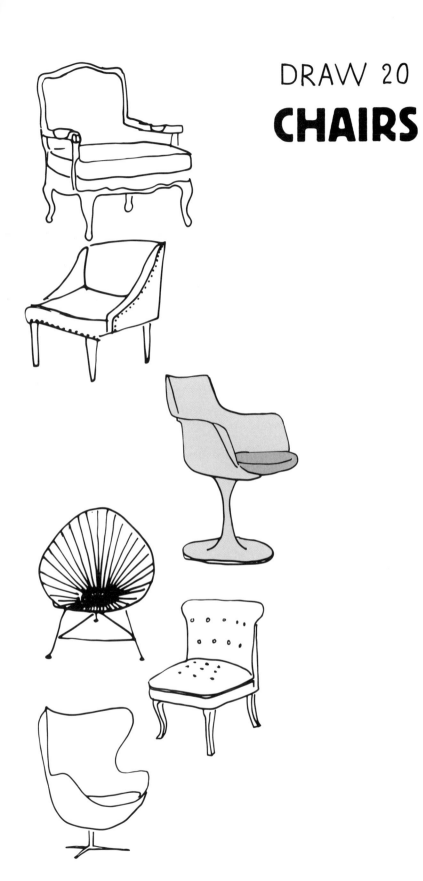

CHAIRS

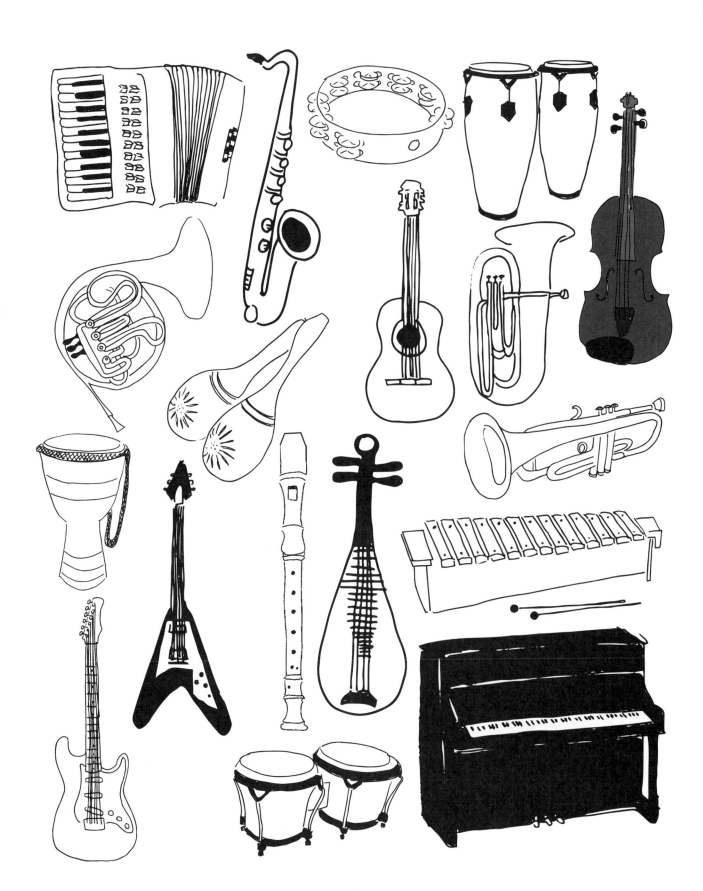

DRAW 20
MUSICAL INSTRUMENTS

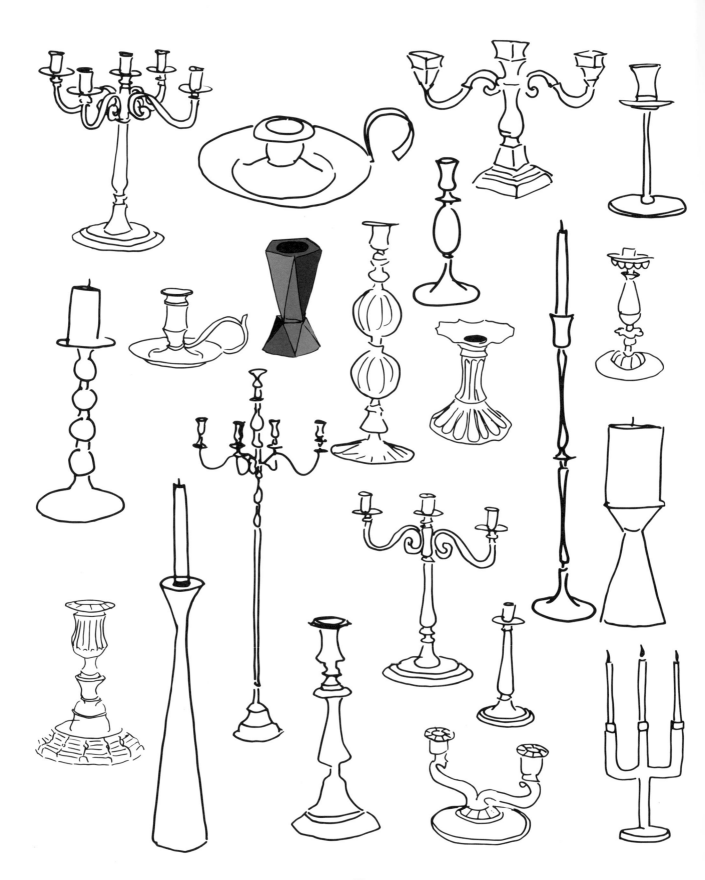

Candlesticks

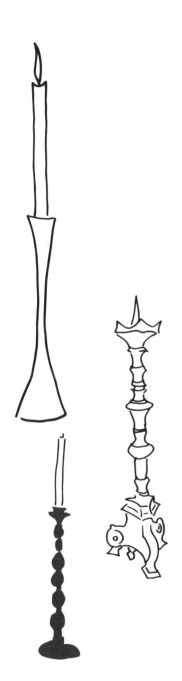

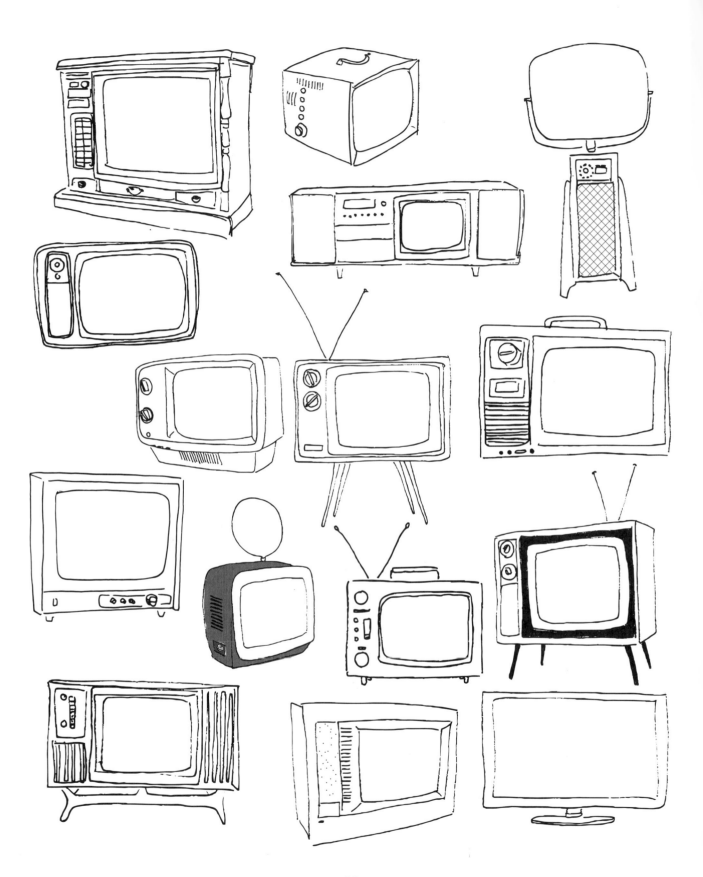

DRAW 20
TELEVISIONS

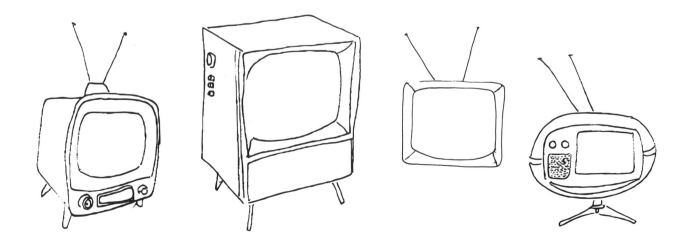

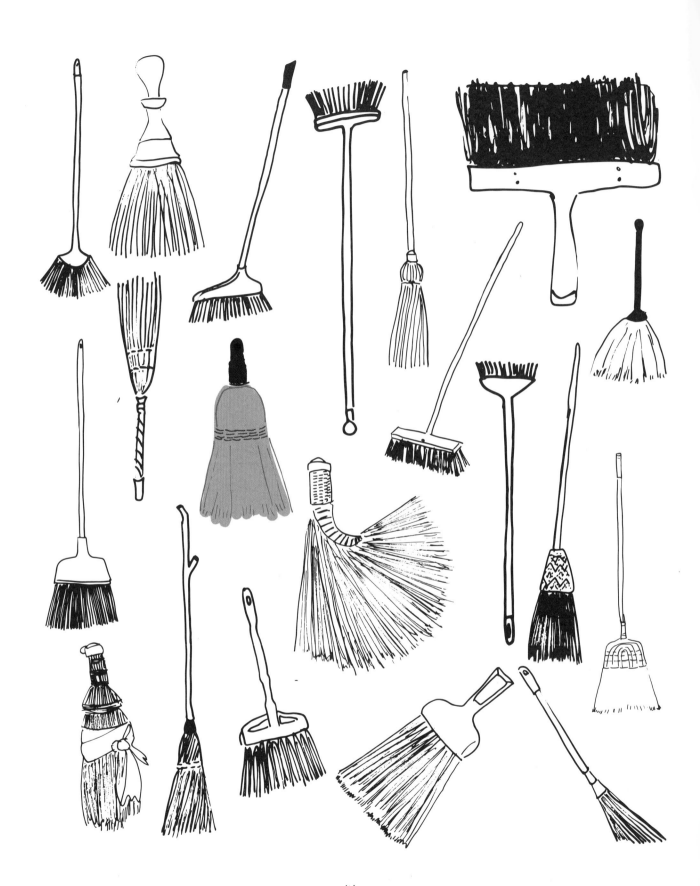

DRAW 20
BROOMS

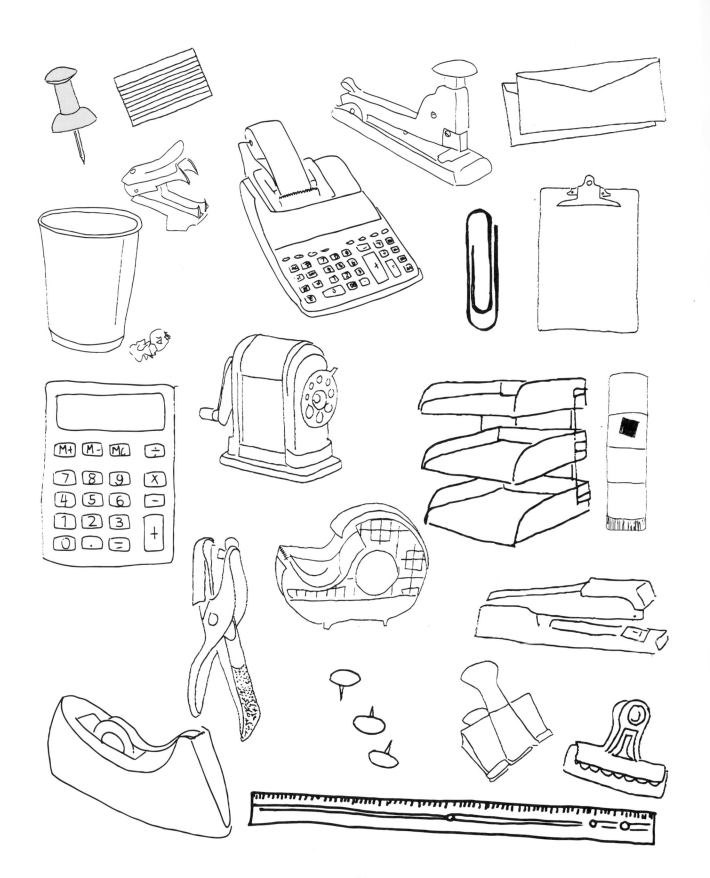

DRAW 20
OFFICE SUPPLIES

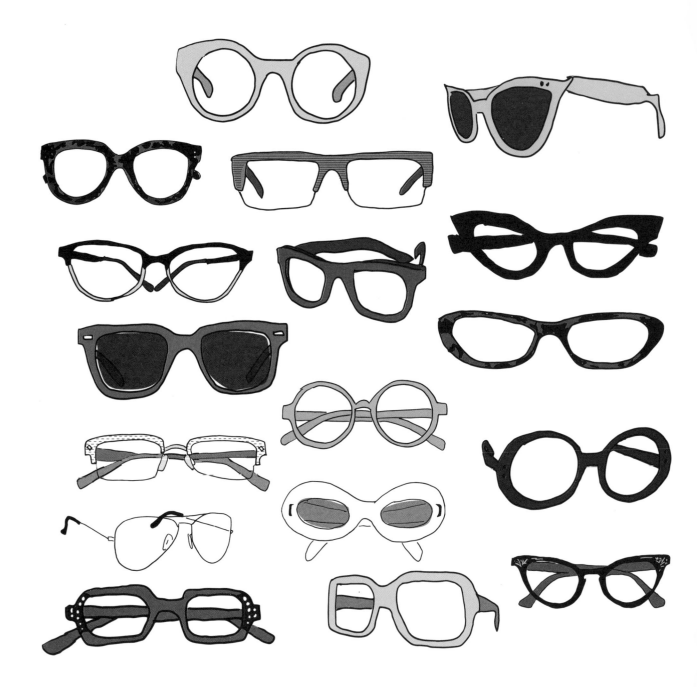

DRAW 20
Eyeglasses

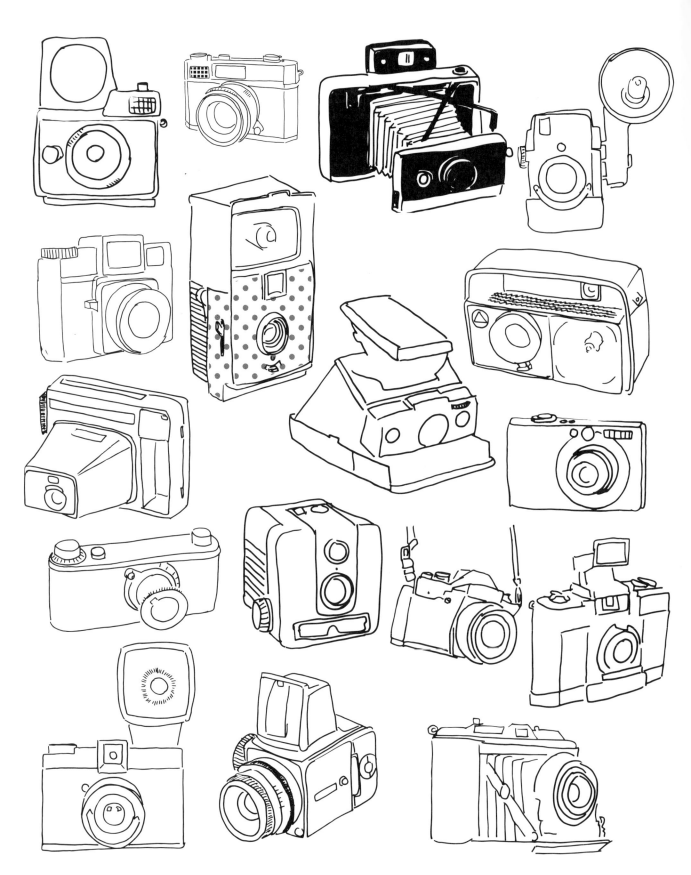

DRAW 20
CAMERAS

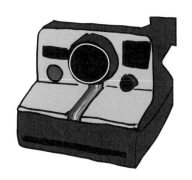

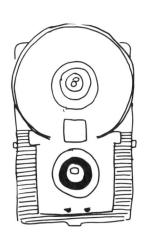

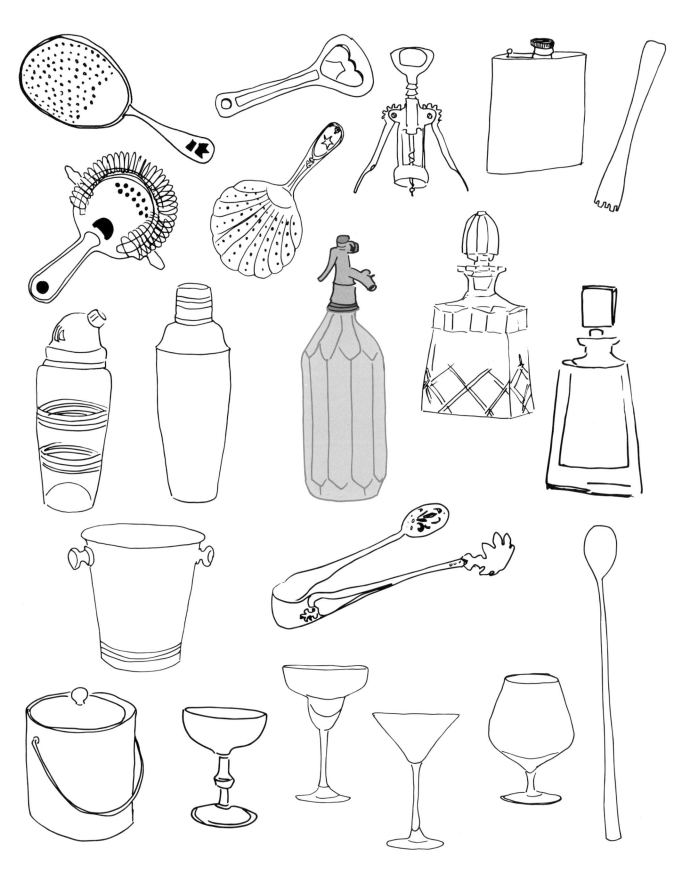

DRAW 20
BARWARE

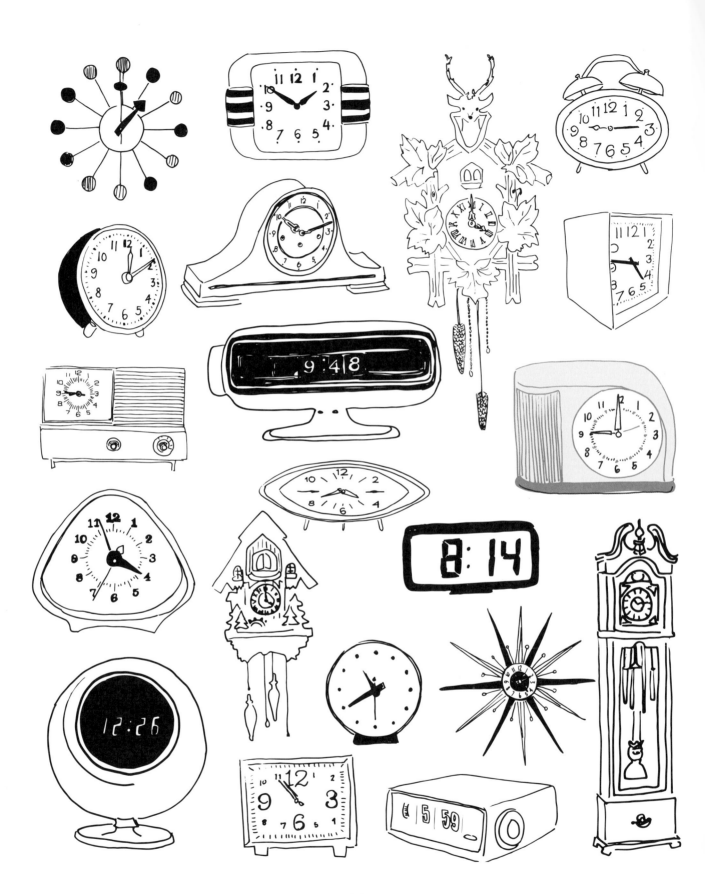

DRAW 20
CLOCKS

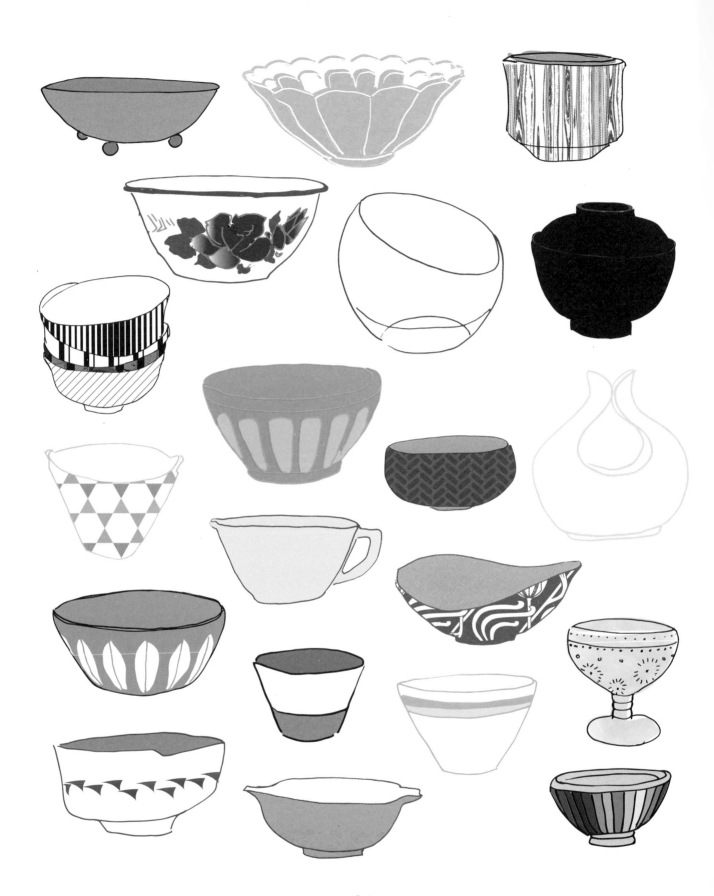

DRAW 20
bowls

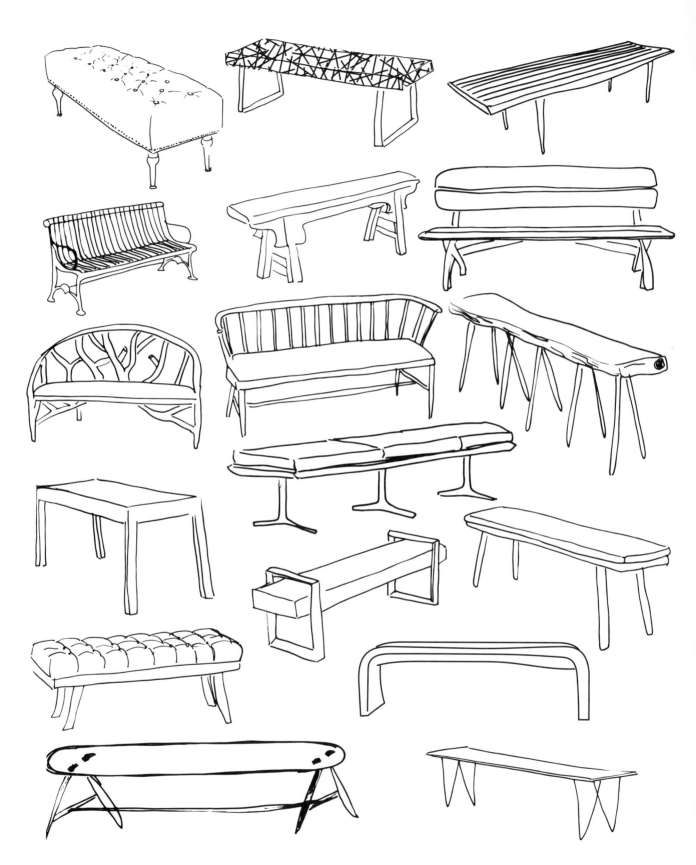

DRAW 20
BENCHES

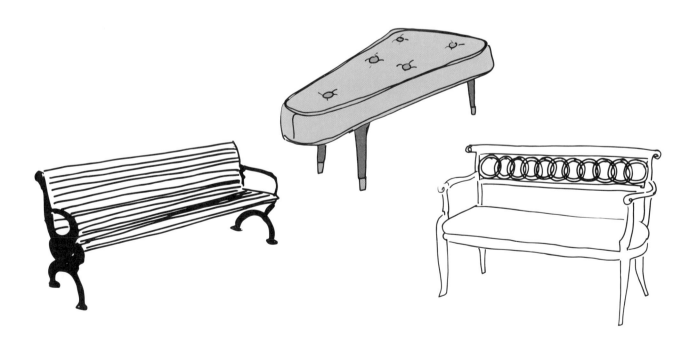

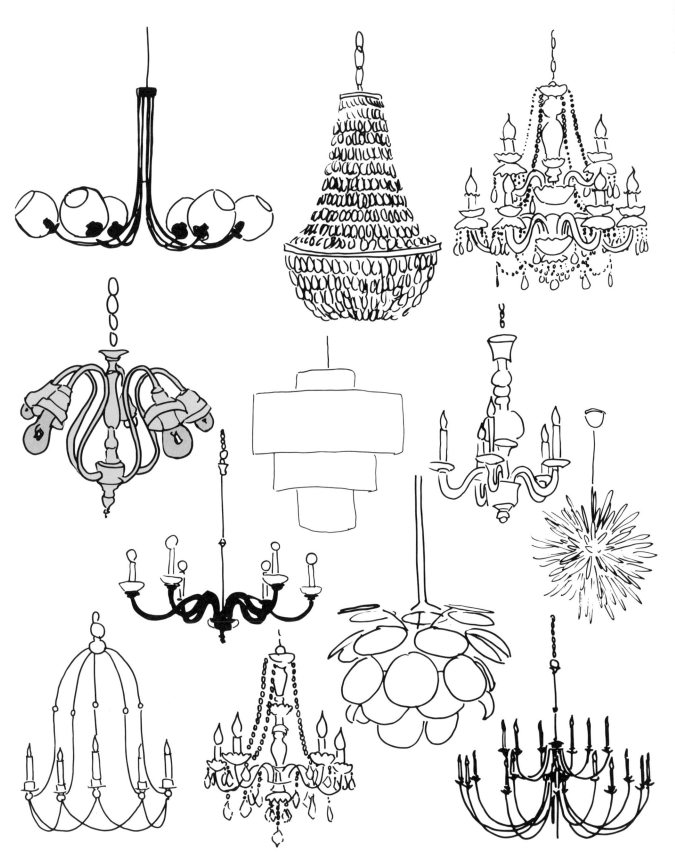

DRAW 20
CHANDELIERS

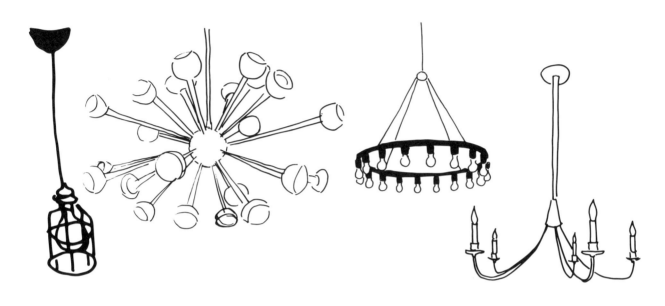

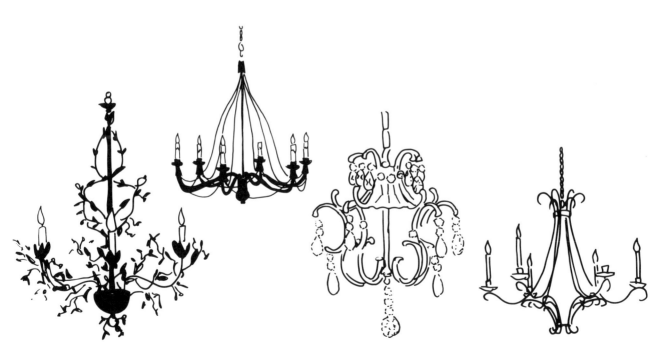

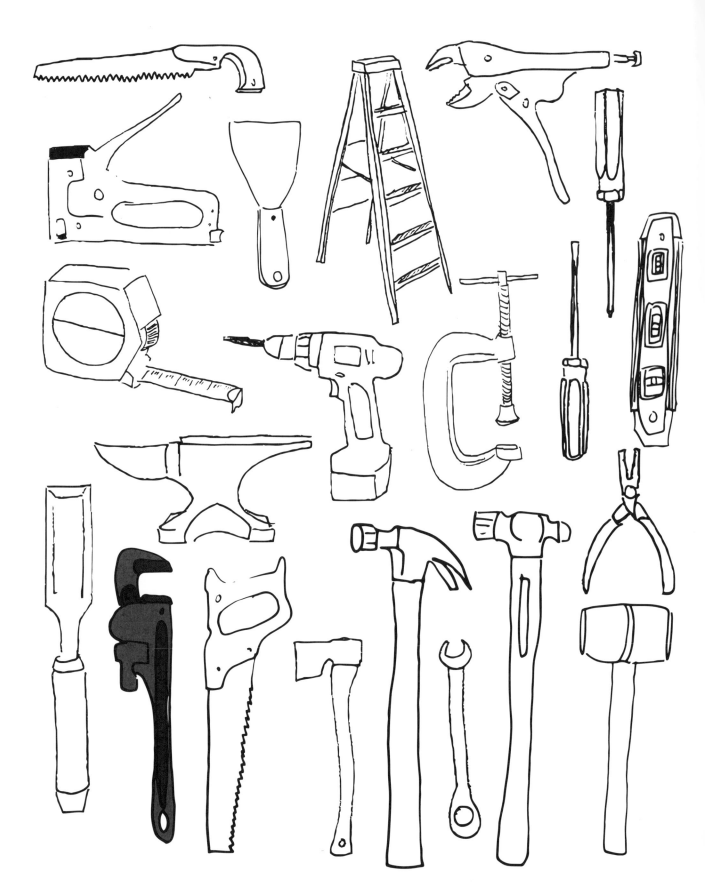

DRAW 20
TOOLS

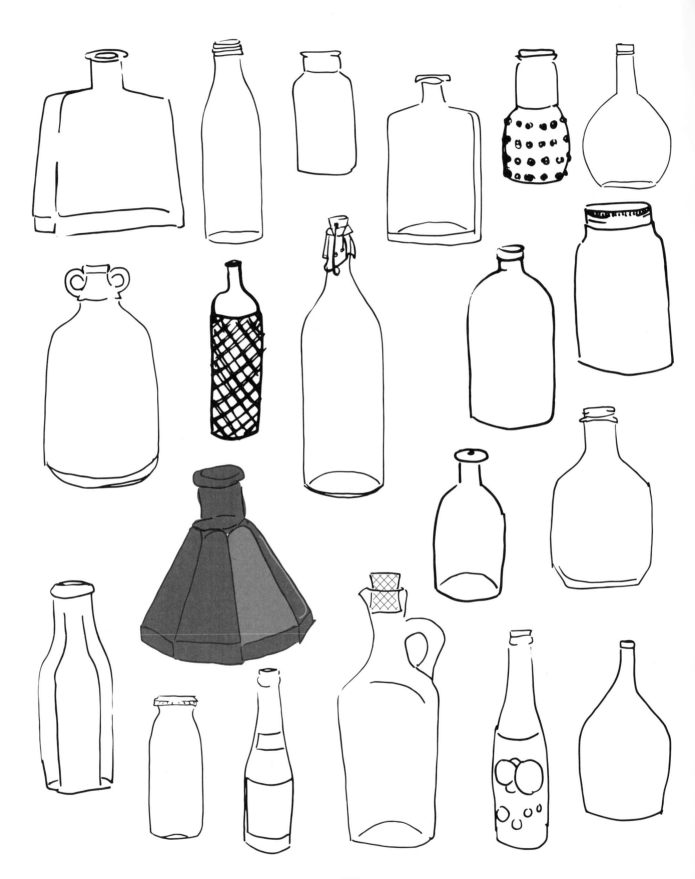

DRAW 20
BOTTLES

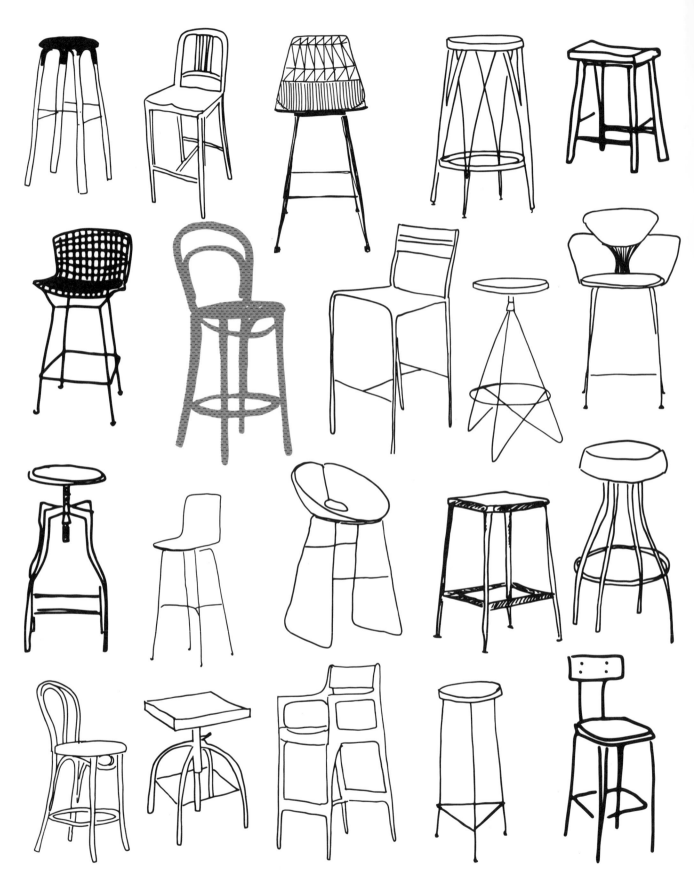

DRAW 20
STOOLS

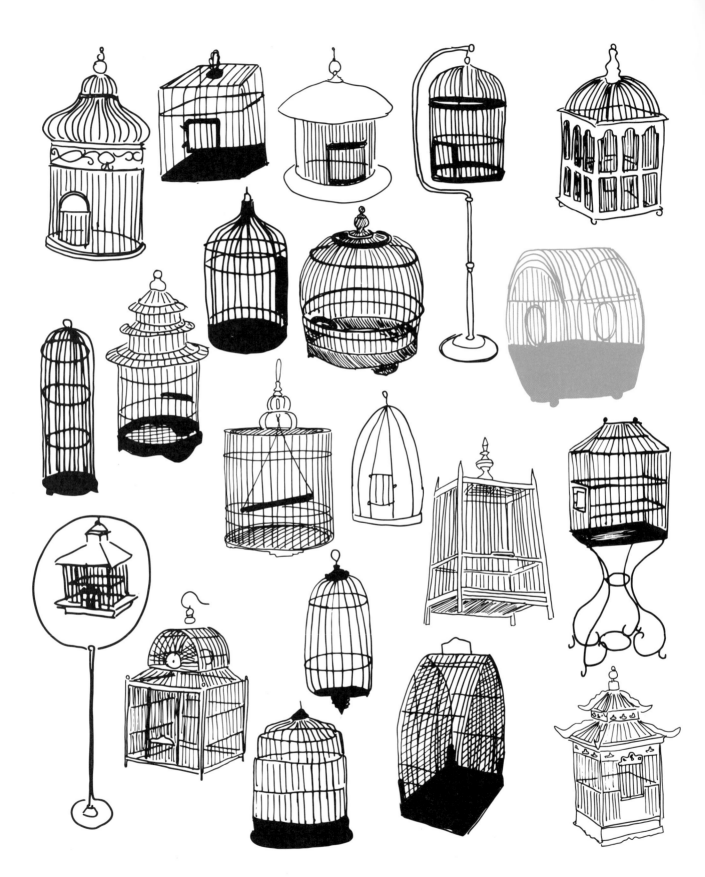

DRAW 20
BIRDCAGES

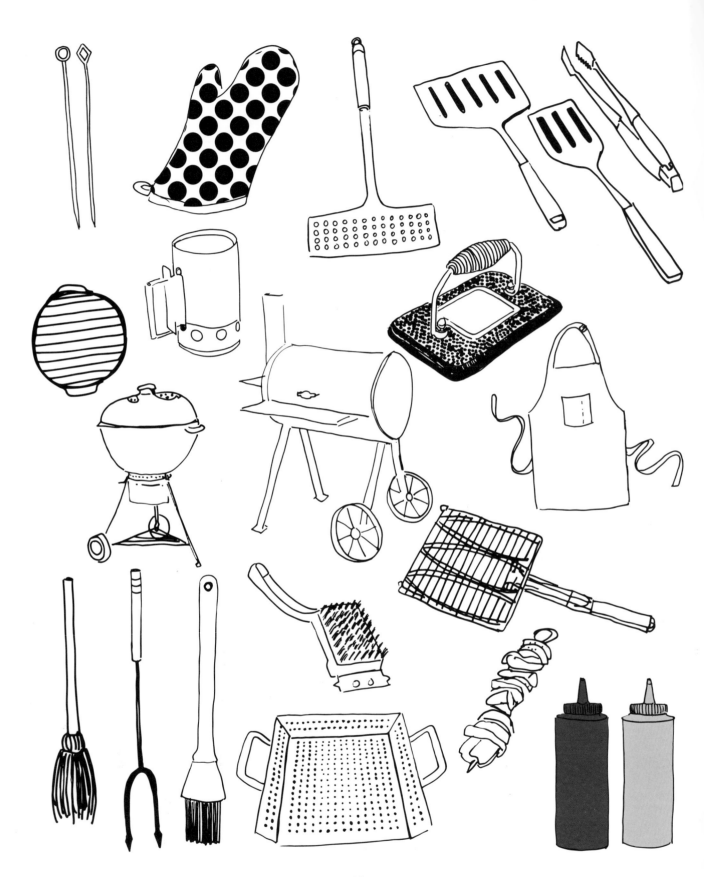

DRAW 20
GRILLING TOOLS

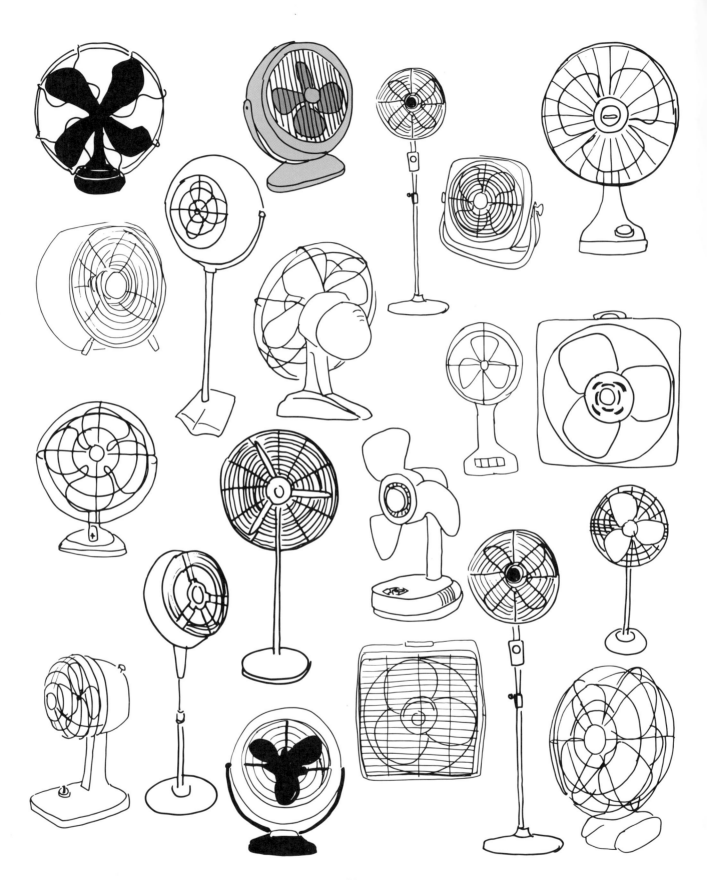

DRAW 20
Fans

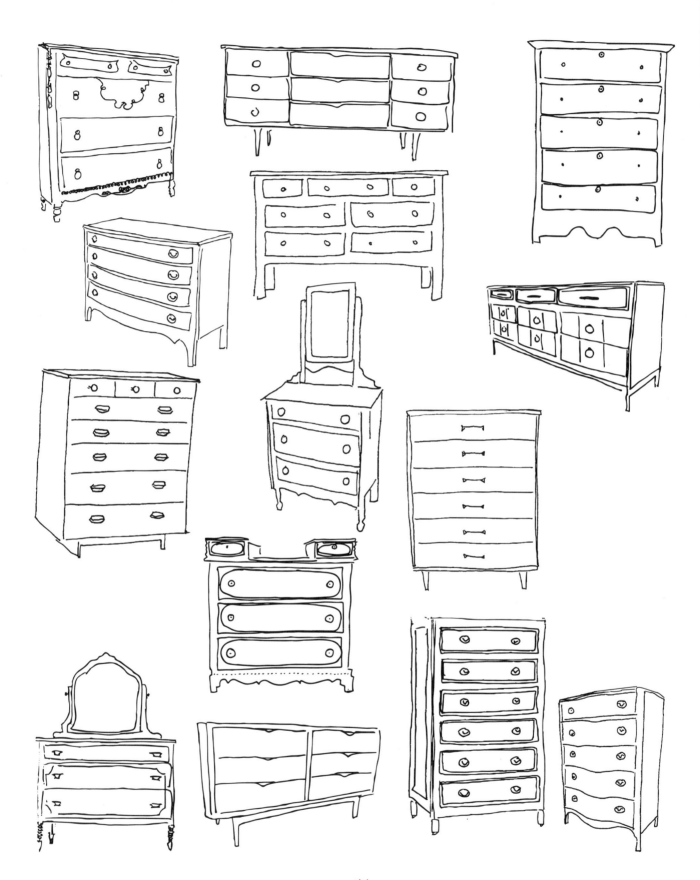

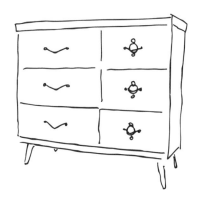

DRAW 20
DRESSERS

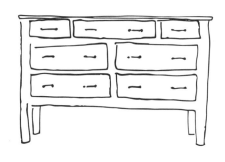

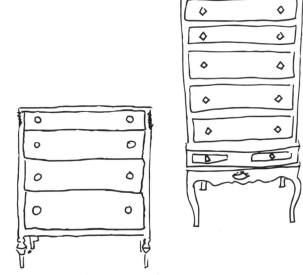

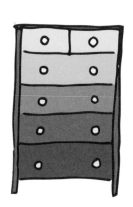

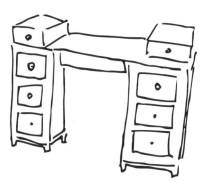

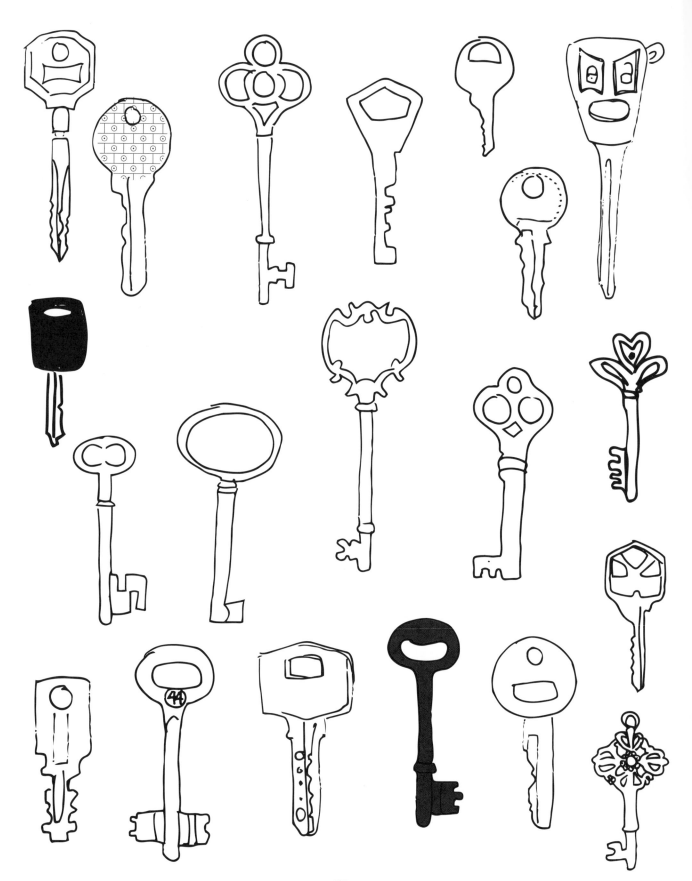

DRAW 20

Keys

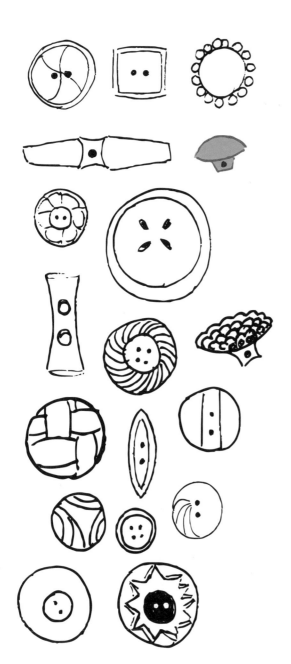

DRAW 20
BUTTONS

DRAW 20
HOUSEPLANTS

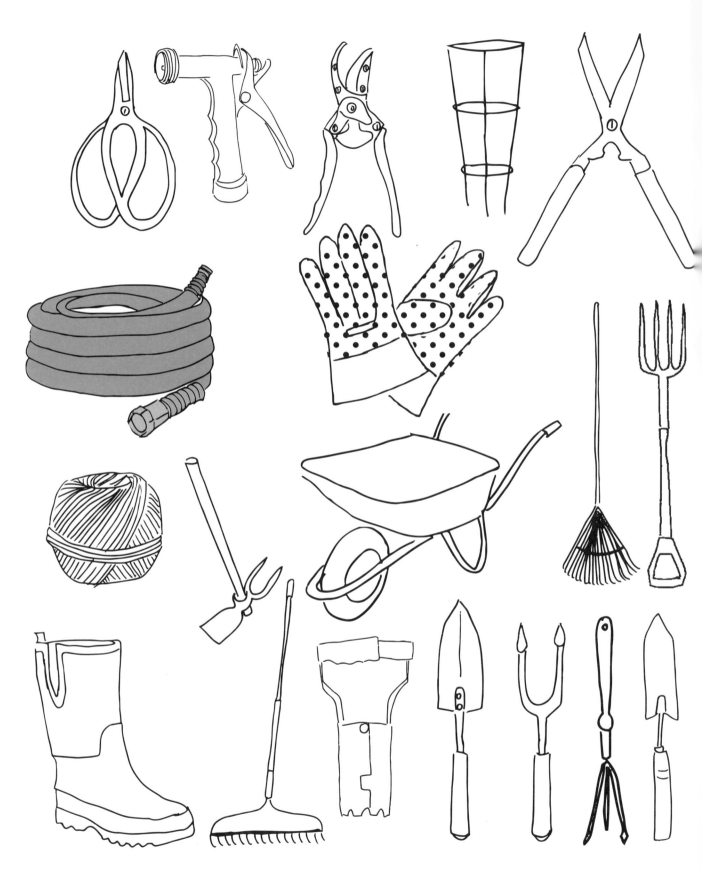

DRAW 20
Garden Tools

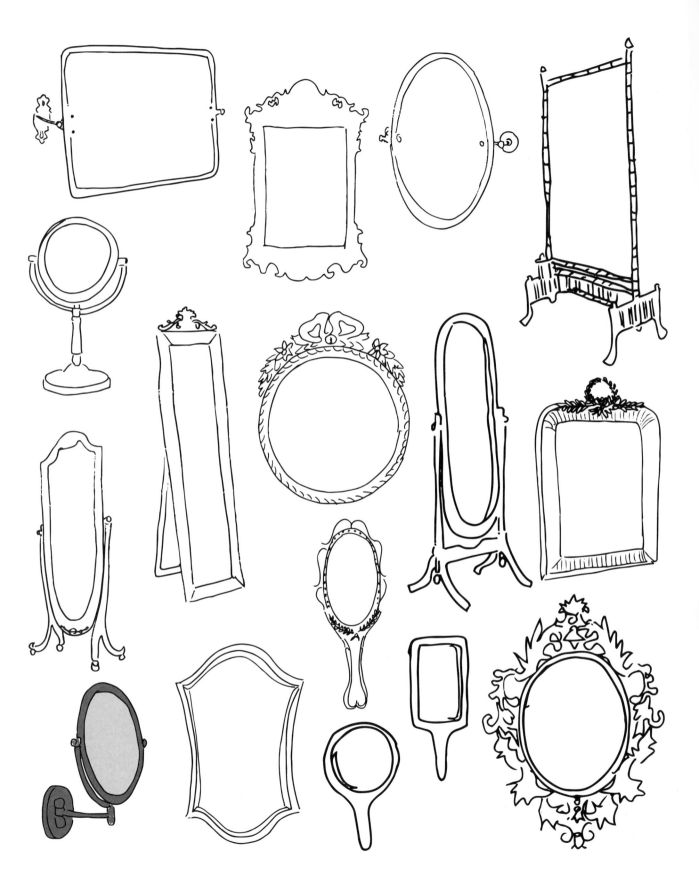

DRAW 20
Mirrors

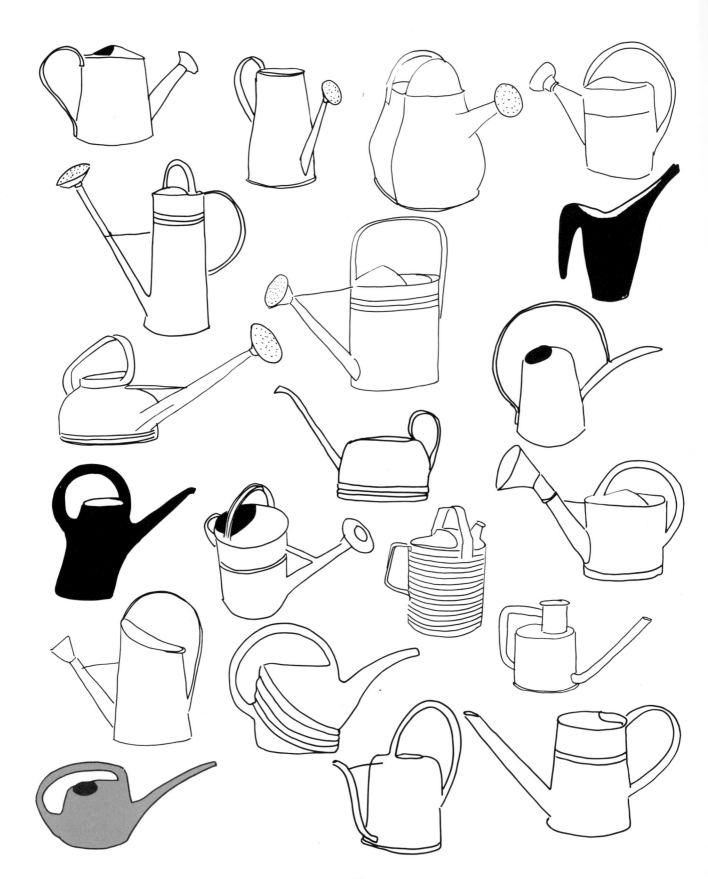

DRAW 20
Watering Cans

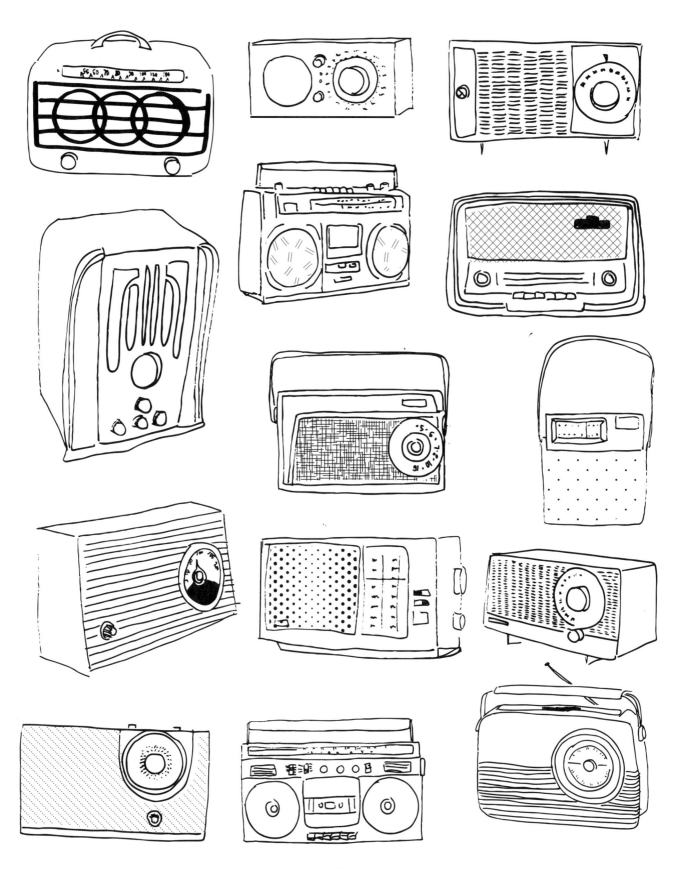

DRAW 20
RADIOS

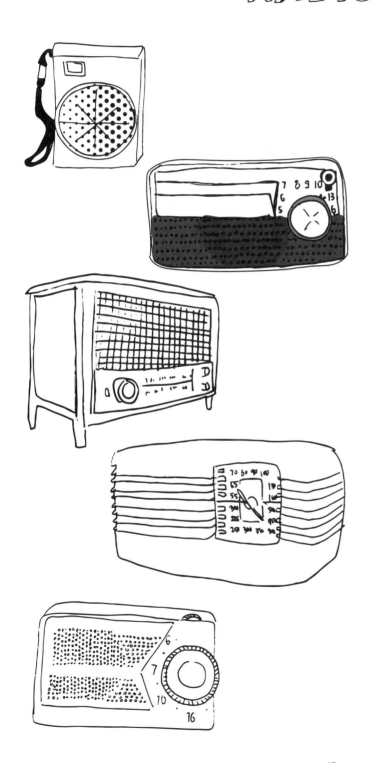

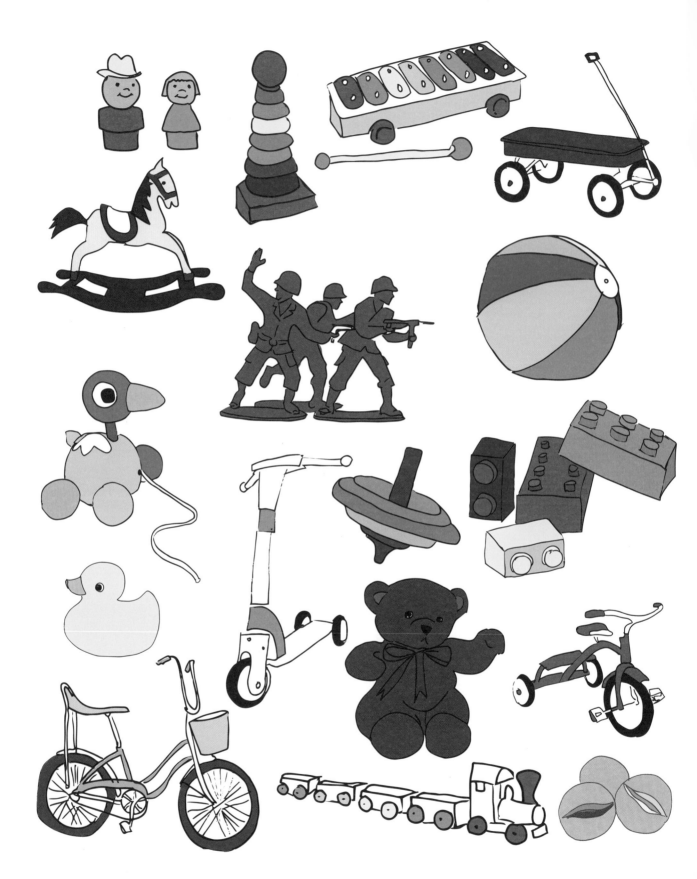

DRAW 20
TOYS

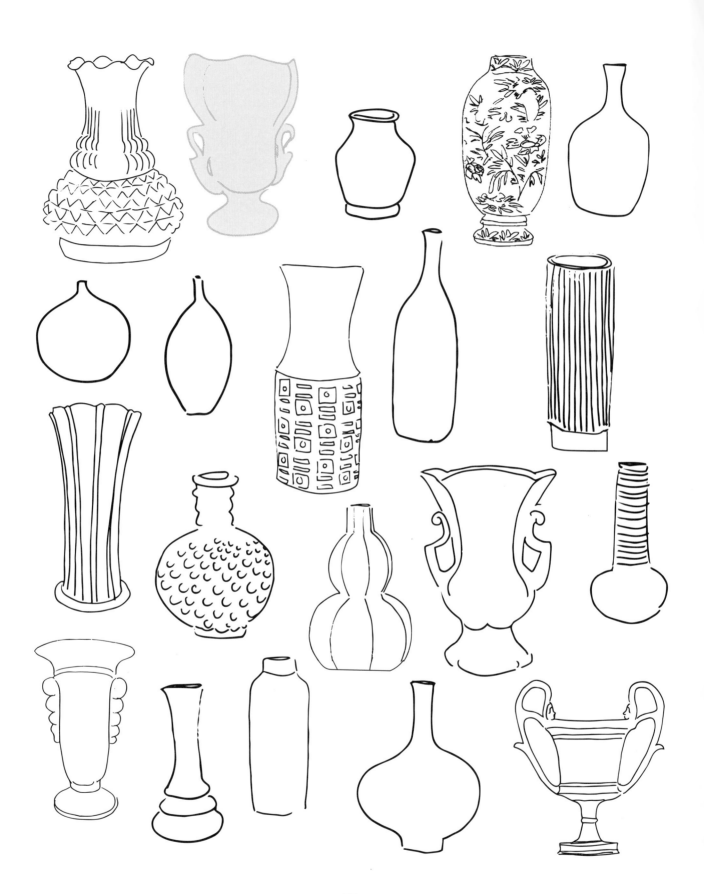

DRAW 20

Vases

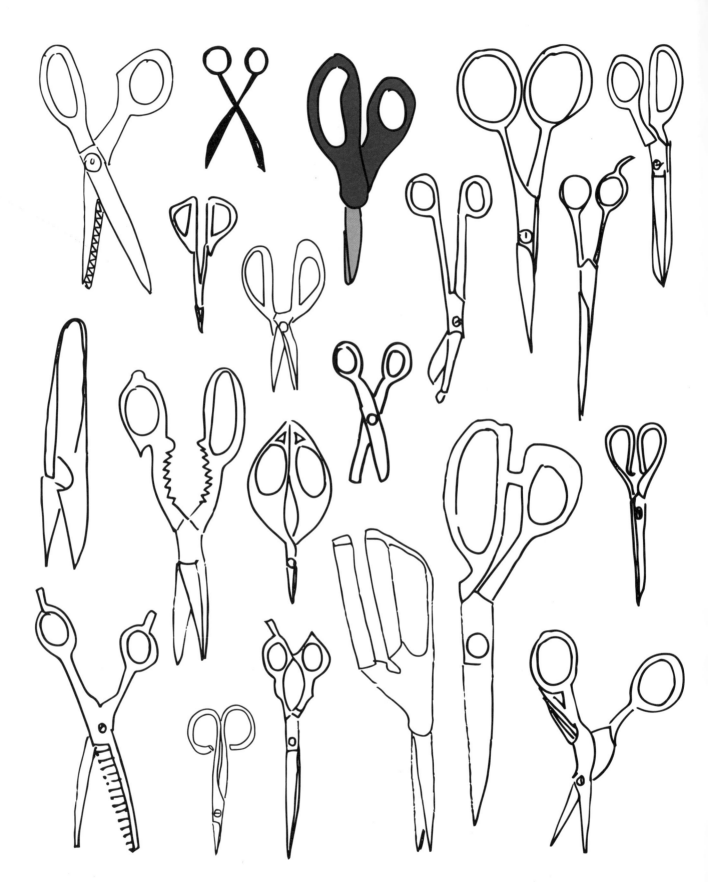

DRAW 20
SCISSORS

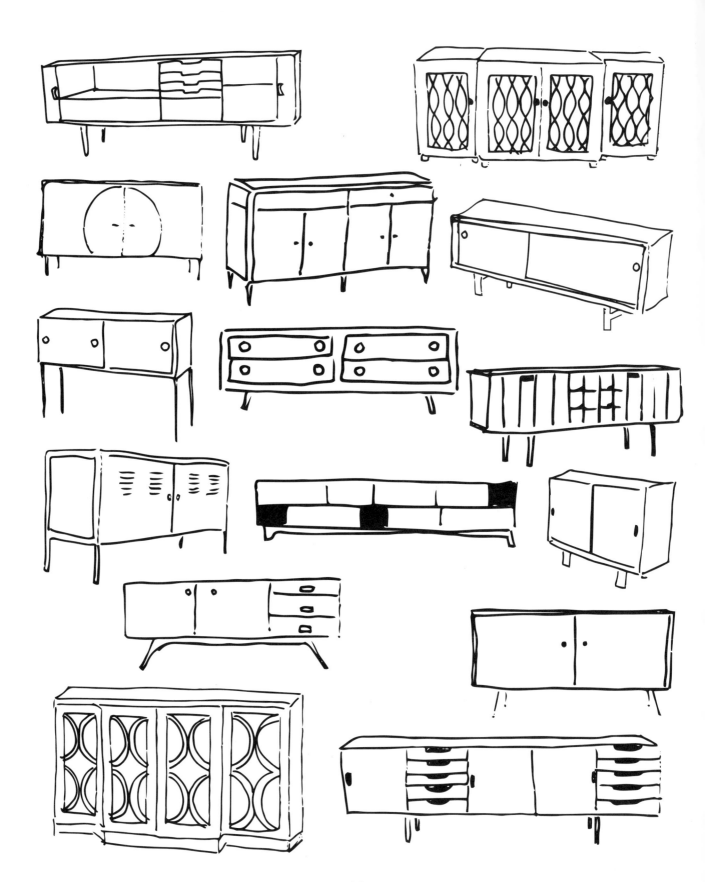

DRAW 20
Credenzas

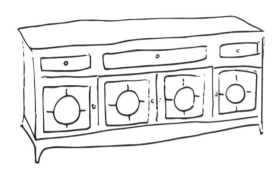

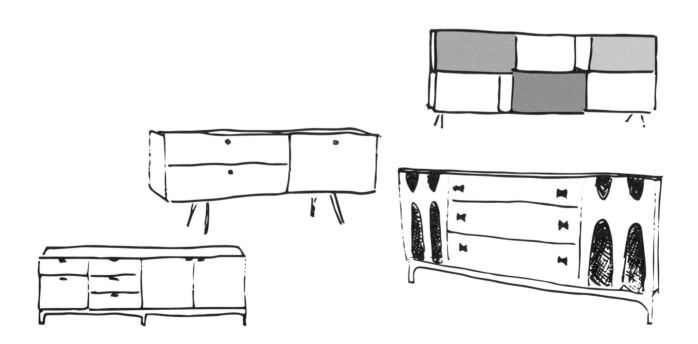

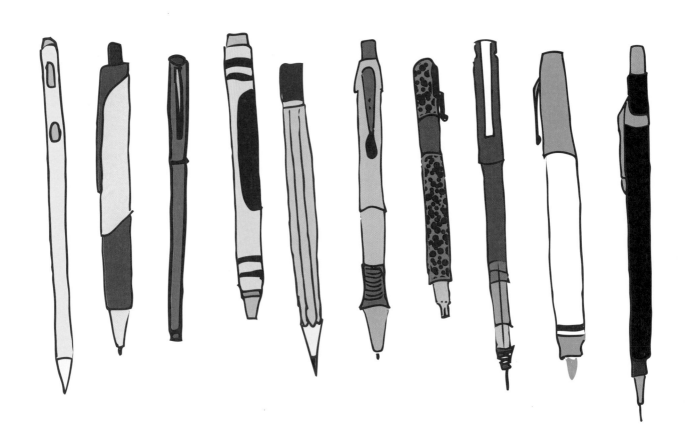

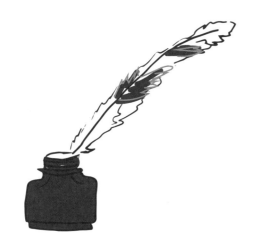

DRAW 20
Writing Tools

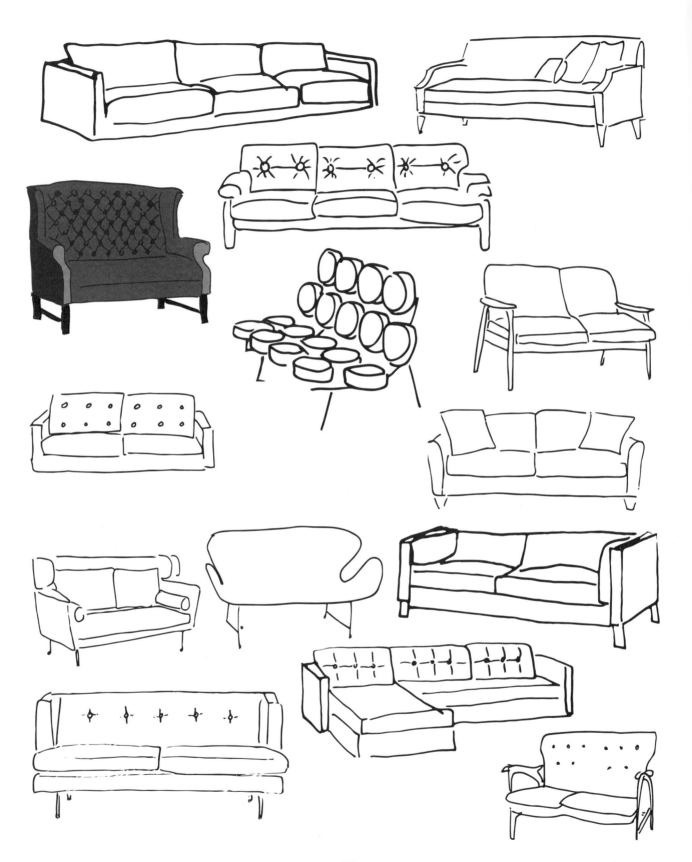

DRAW 20
SOFAS

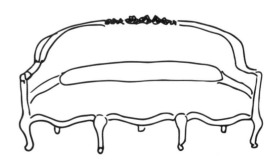

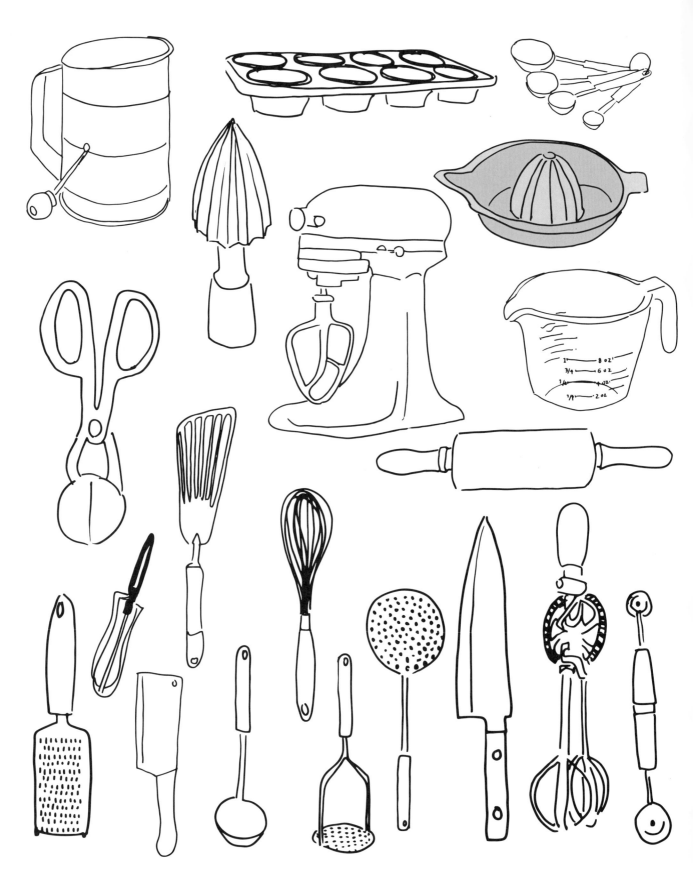

DRAW 20
Kitchen Utensils

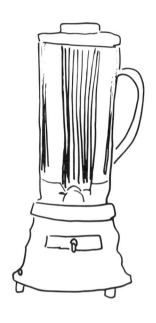

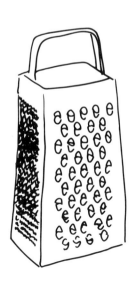

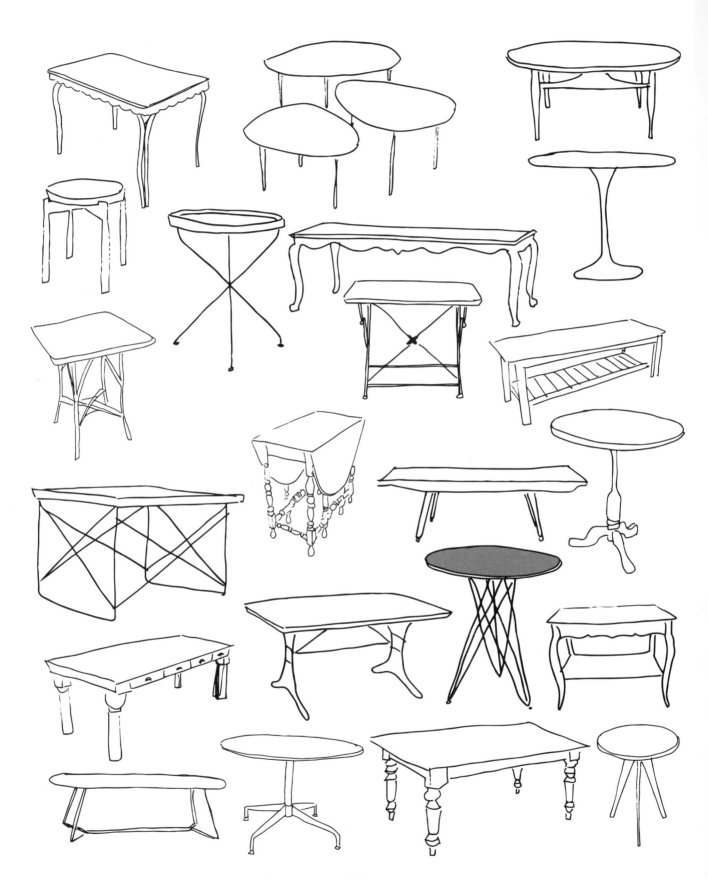

DRAW 20
TABLES

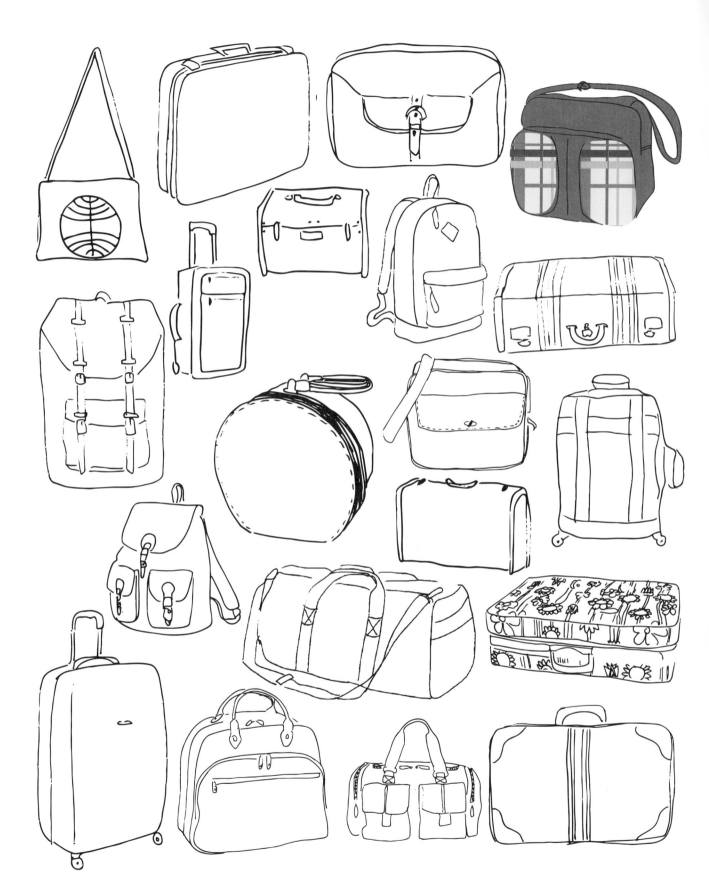

DRAW 20
SUITCASES

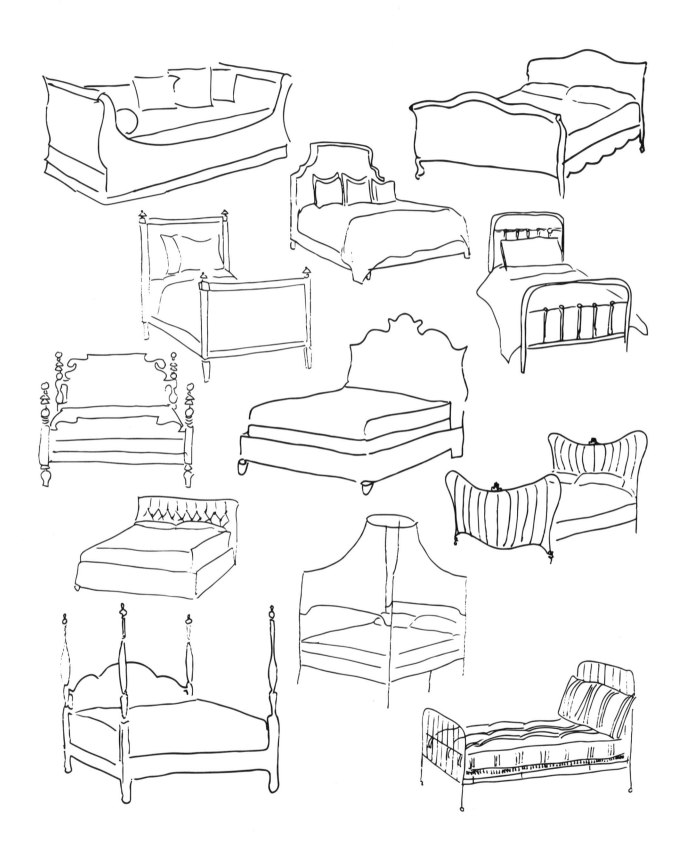

DRAW 20
Beds

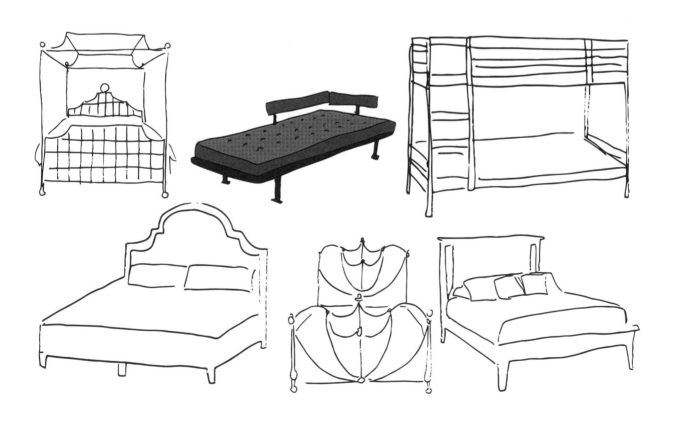

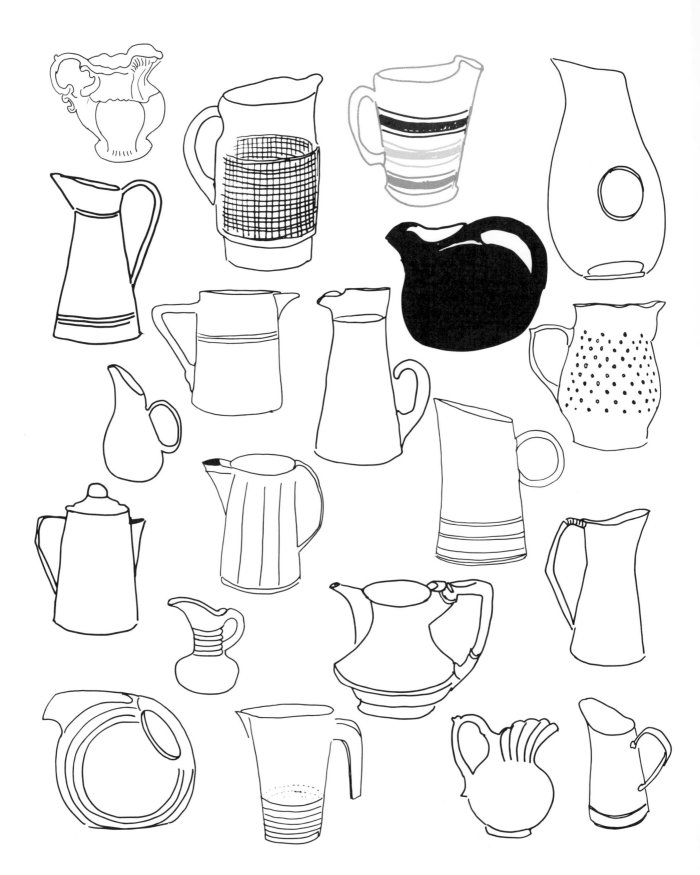

DRAW 20
PITCHERS

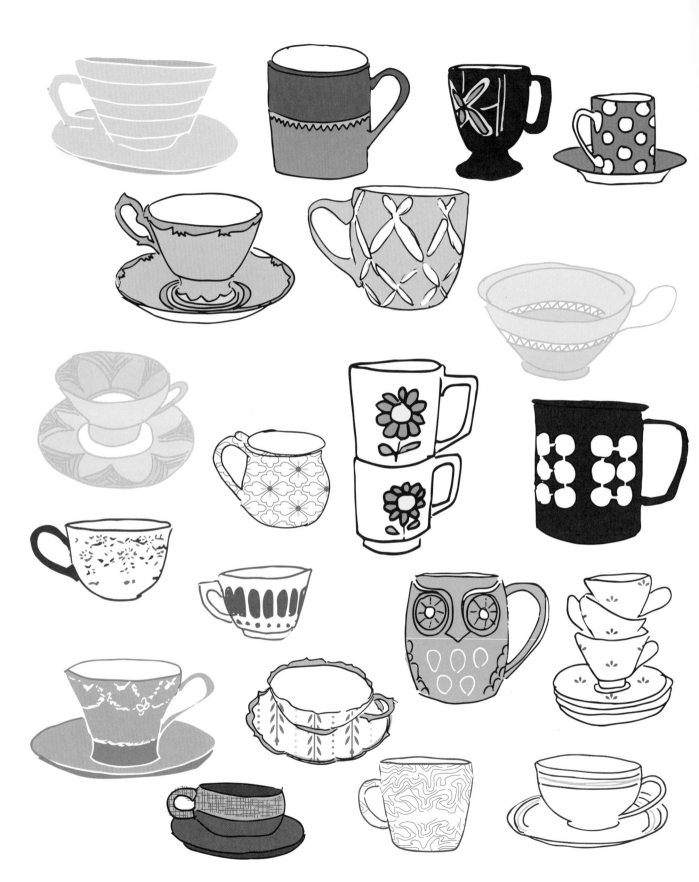

DRAW 20
Teacups & Mugs

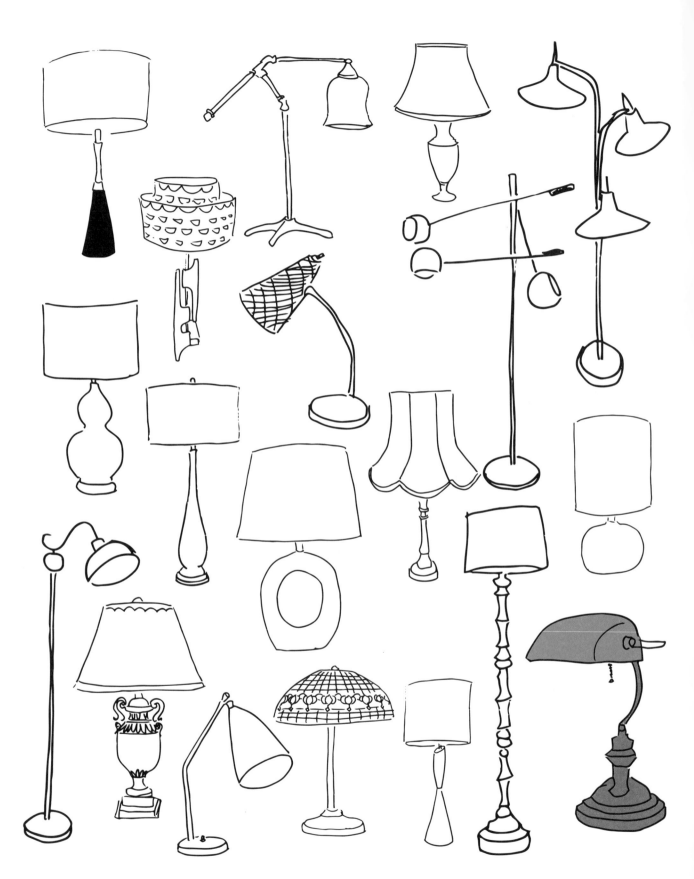

DRAW 20
LAMPS

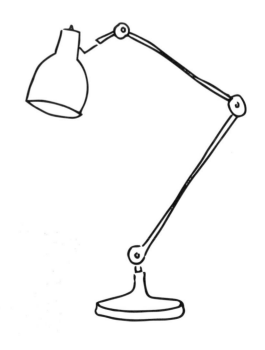

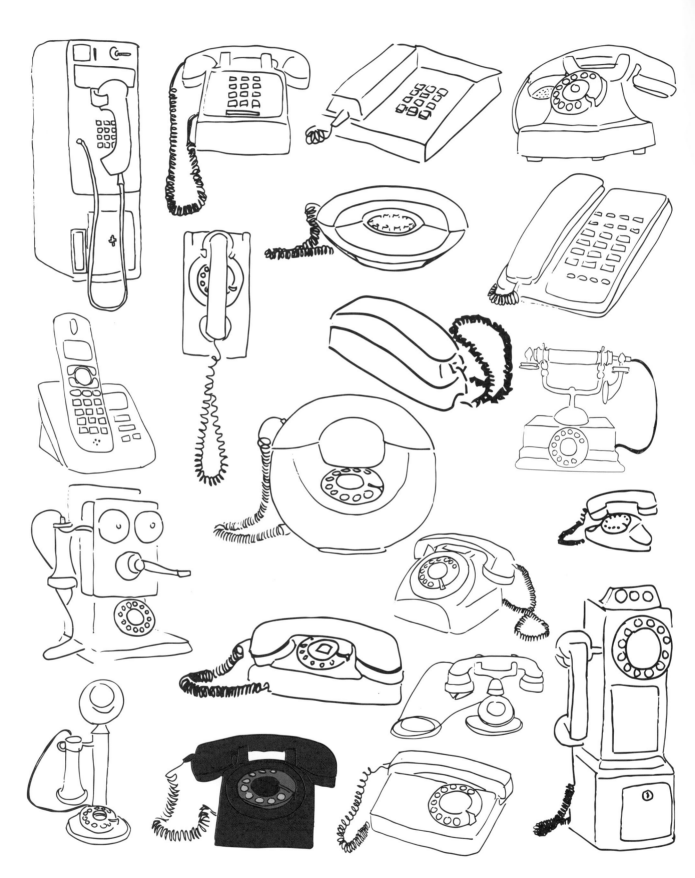

DRAW 20
TELEPHONES

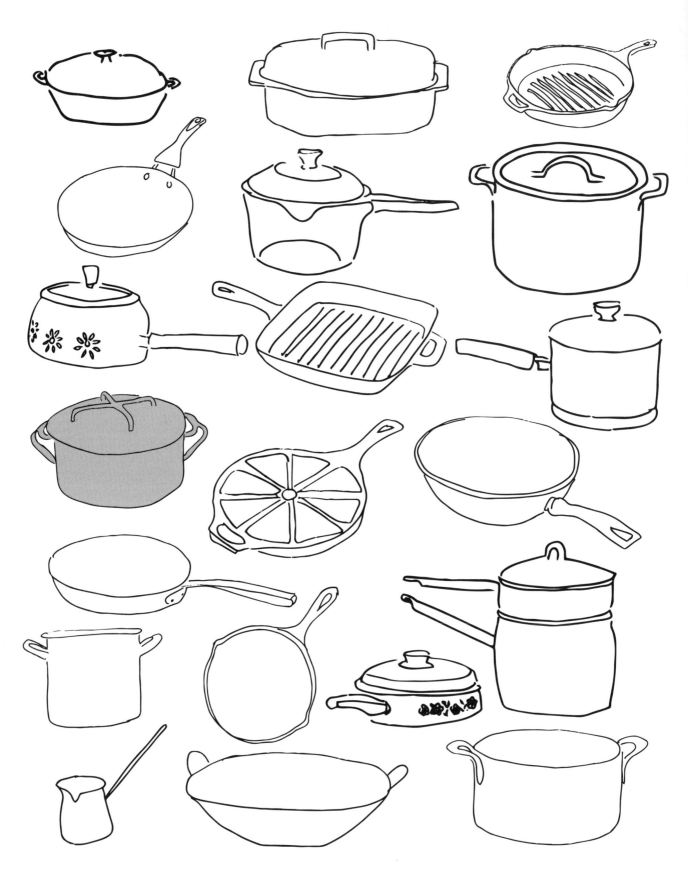

DRAW 20
Pots & Pans

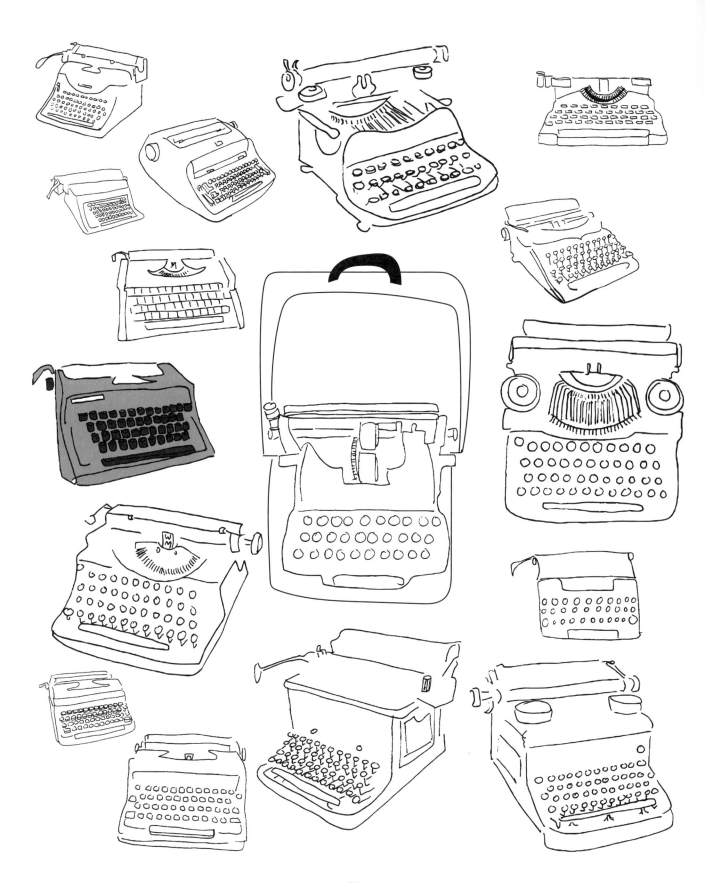

DRAW 20
Typewriters

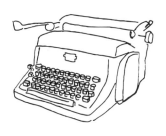

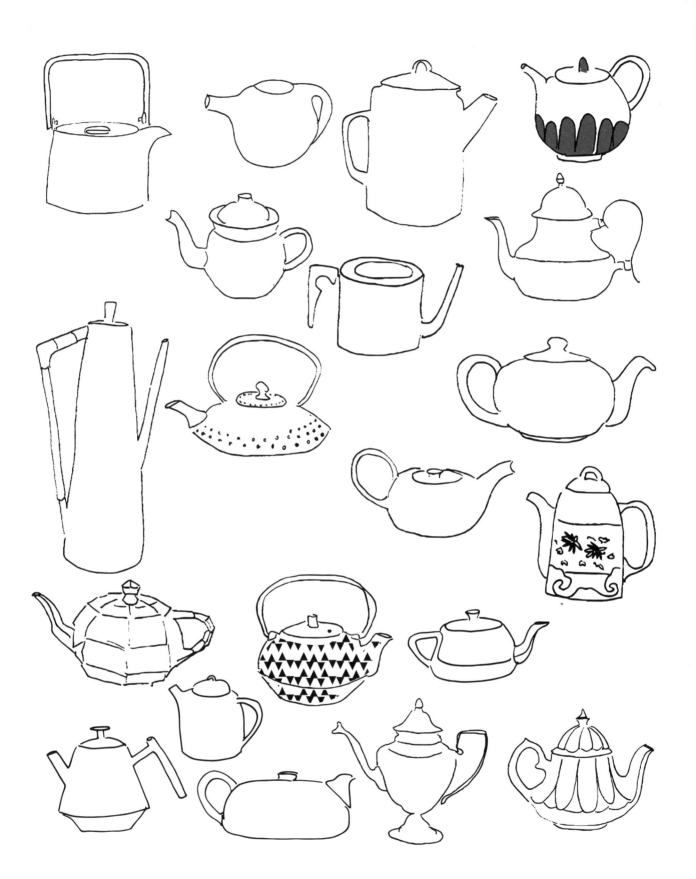

DRAW 20
TEAPOTS

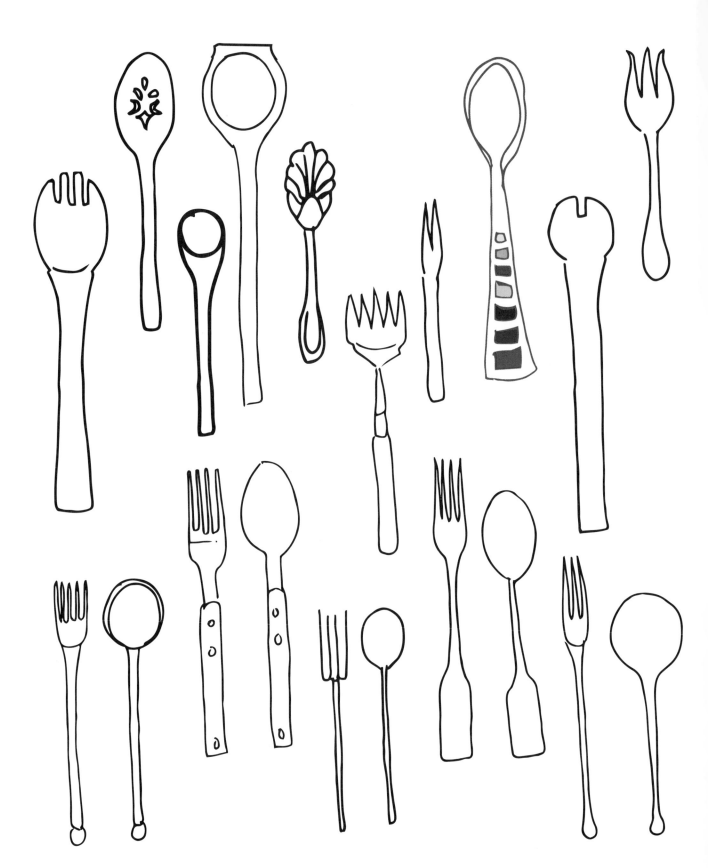

DRAW 20
Forks & Spoons

ABOUT THE ARTIST

Lisa Solomon is a mixed-media artist based in the Bay Area who moonlights as a professor, graphic designer, and illustrator. She often questions and deconstructs the meaning of identity and personal histories through the use of mediums traditionally associated with domestic crafts—particularly embroidery and crochet. A "happa," (one-half Japanese, one-half Caucasian), she feels as though hybridization is continually at play in her work. She exhibits her artwork both nationally and internationally including such venues as the Ulrich Museum in Wichita, Kansas, the Oakland Museum of California, the Koumi Machi Museum in Nagano, Japan, the Walter Maciel Gallery in Los Angeles, the Fouladi Projects in San Francisco, and Gallery Nicoletta Rusconi in Milan, Italy. She is also the author of *Knot Thread Stitch: Exploring Creativity through Embroidery and Mixed Media*, (Quarry Books, 2012). In 2013, MIEL press published a monograph of her work. Lisa shares her home with her husband, a young daughter, a bevy of pets, and many, many spools of thread. See more of her work at lisasolomon.com.